betty and rita go to paris

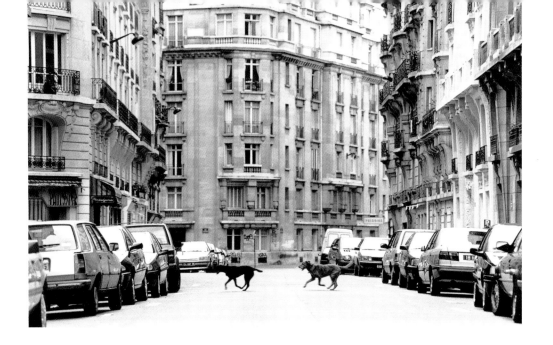

Text by Judith E. Hughes

Photographs by Michael Malyszko

CHRONICLE BOOKS
SAN FRANCISCO

Printed in Singapore.

ISBN 0-8118-2370-9

Library of Congress Cataloging-in-Publication
Data available.

Book and cover design: Shawn Hazen
Cover photograph: Michael Malyszko

Distributed in Canada by
Raincoast Books
8680 Cambie Street
Vancouver, B.C. V6P 6M9

10 9 8 7 6 5 4 3

Chronicle Books
85 Second Street
San Francisco, California 94105

www.chroniclebooks.com

A special merci *to our bright and beautiful daughter, Maeve, without whose sublime adaptability to the new and challenging we could never even have considered a year abroad, and whose helpful hands and quick commands made all the difference to so many of these photographs.*

We're Betty and Rita, two traveling pups,

who took off for Paris and did the town up.

Our cab zipped us up les Champs-Élysées

where traffic was light that very first day.

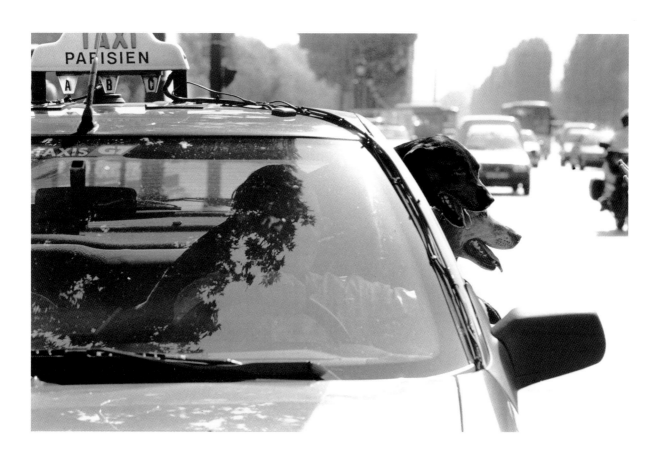

L'Arc de Triomphe was too big for this shot;

scrawny legs and plump bodies were all that we got!

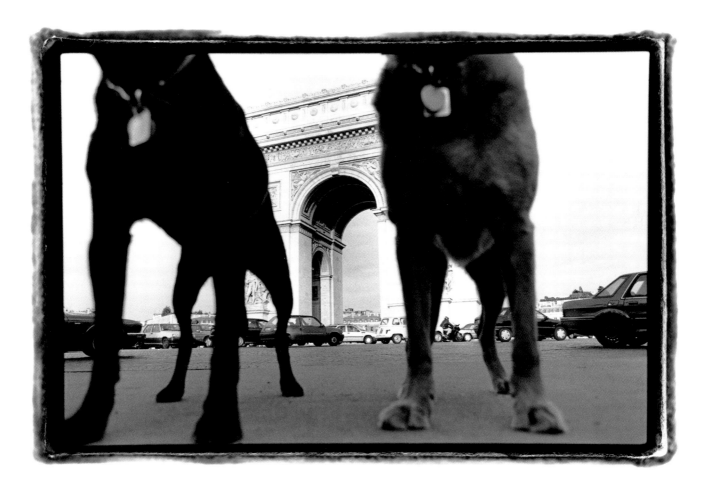

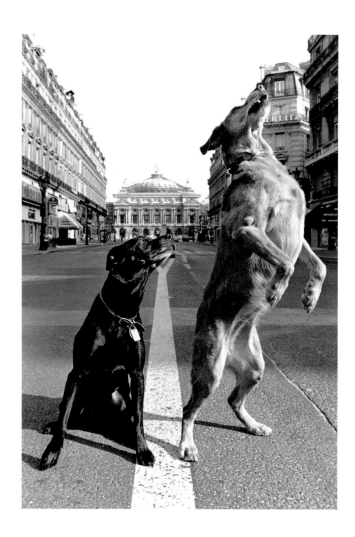

At the old Opéra—now just le ballet—
we gamely attempted a graceful plié.

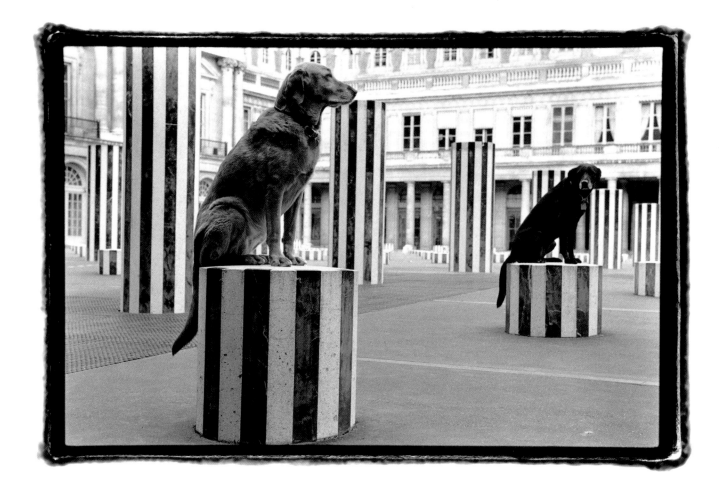

We got the mood right at

le Palais Royal

by climbing the posts and sitting up tall.

At Les Invalides we rolled with delight;

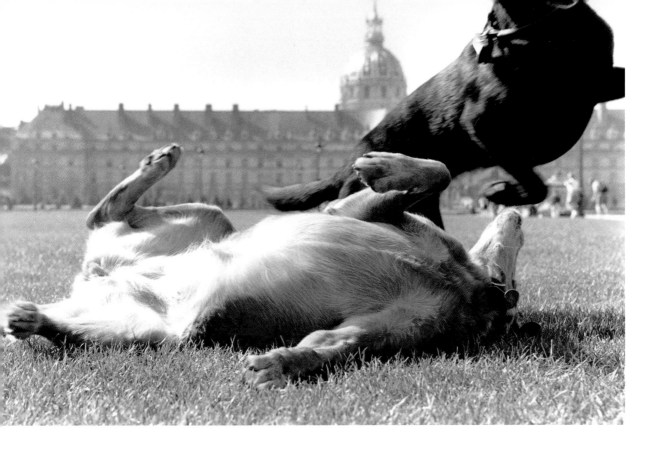

the Corsican's tomb was a beautiful sight.

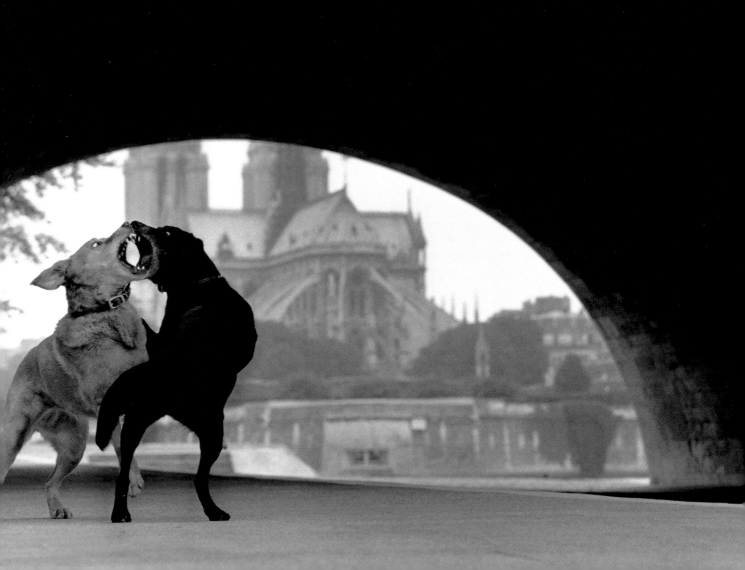

Then, being big dogs in need of some fun,

we saw Notre-Dame, but just on the run.

Three major musées were the second day's fare;

we took l'ascenseur instead of the stairs.

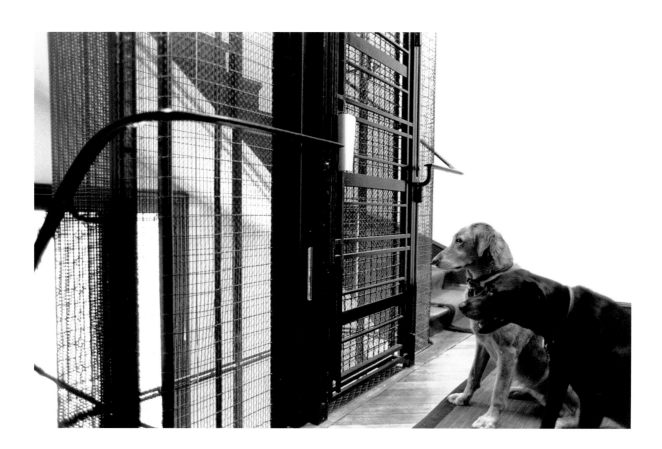

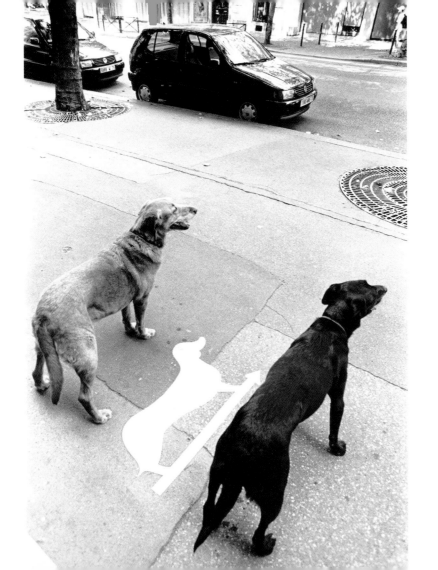

A strange illustration right on la rue

left nothing to chance on where to go poo.

Picasso's tableaux set our jaws all agape,

and we tried it right on with some paper and tape.

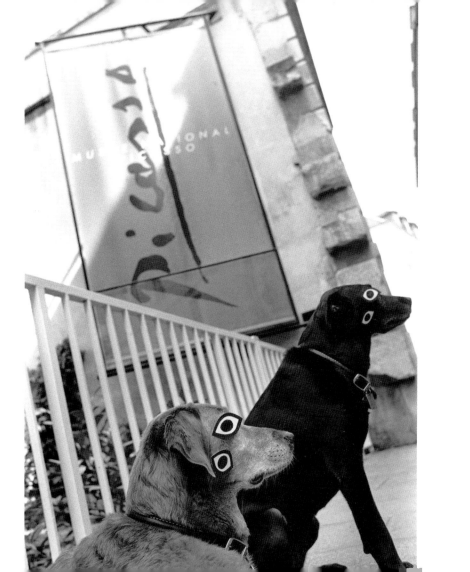

Le Centre Pompidou, across le Marais

looks built inside out and takes a full day.

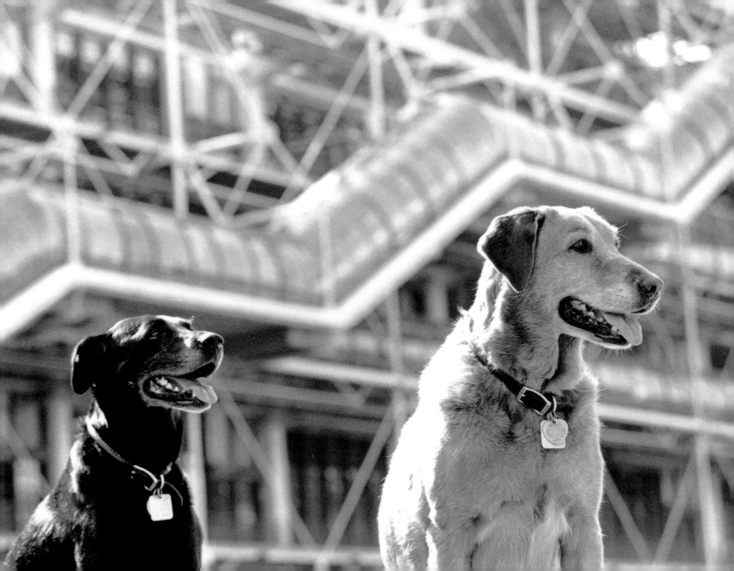

But hurrying through, we went on our way,

to make sure we'd have time to hit

un café.

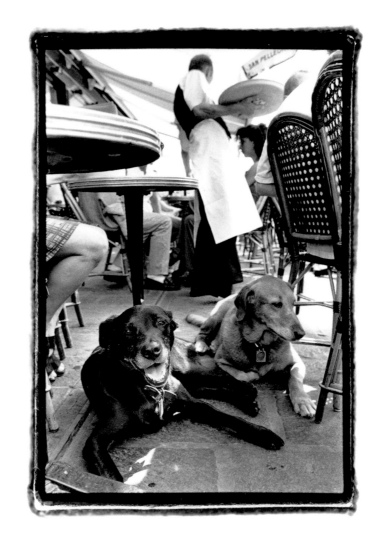

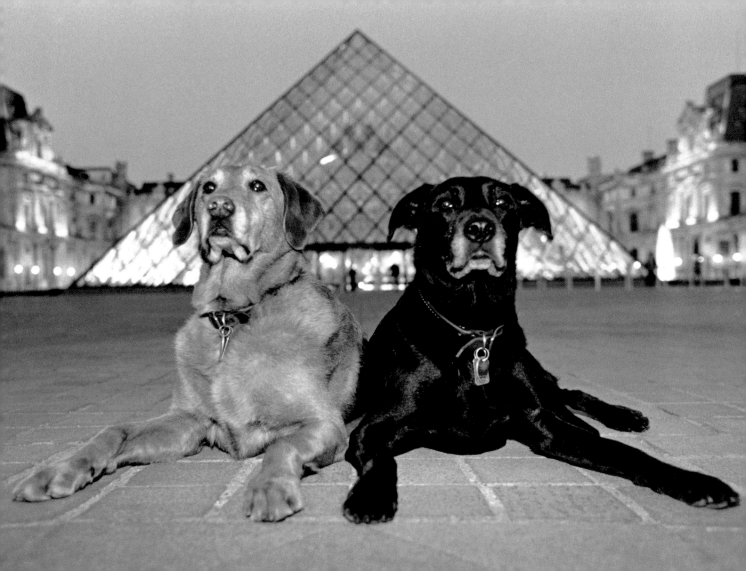

We ended our day au Louvre at sunset,

by the big pyramid—our best photo yet.

Day number three called for something quite new,

so from our balcon we took in the view.

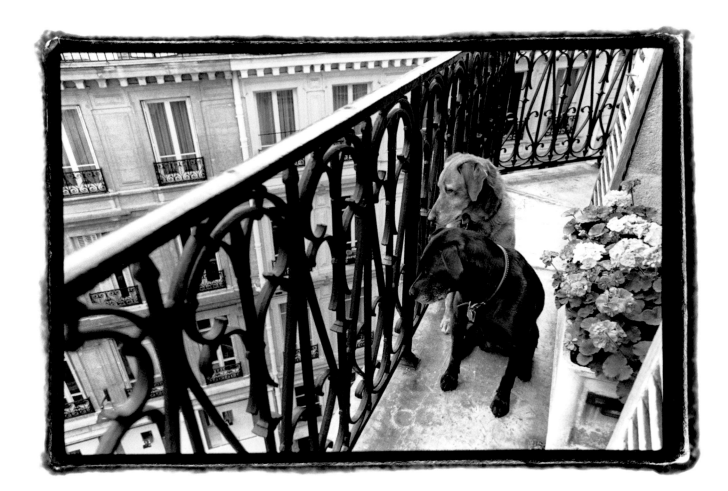

We opted to stay in our own quartier,

not even that hose could drive us away.

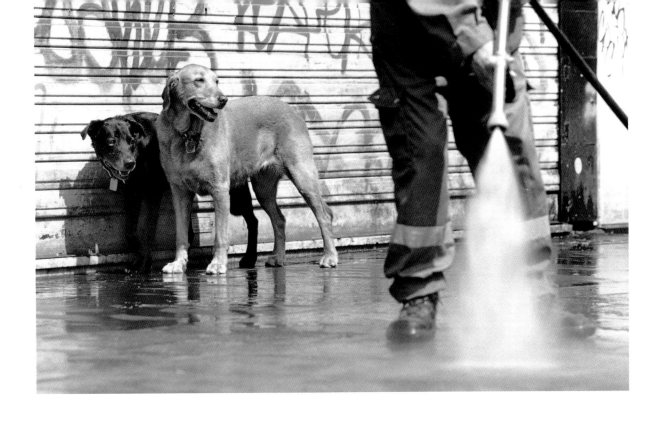

At last in the park once known as Les Halles,

we met un caniche and soon had a pal.

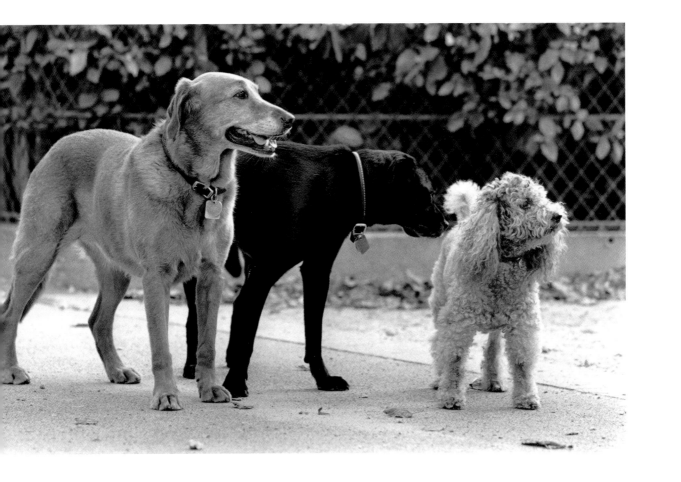

Under the plane trees the men played a game

by throwing a ball—pétanque was the name.

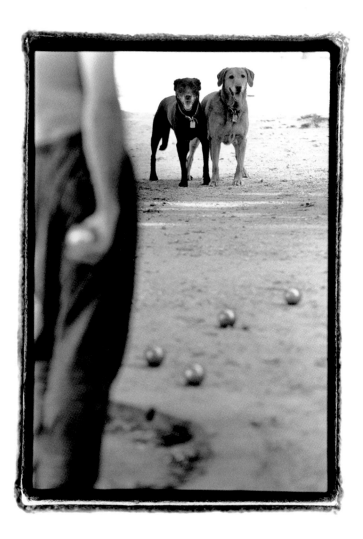

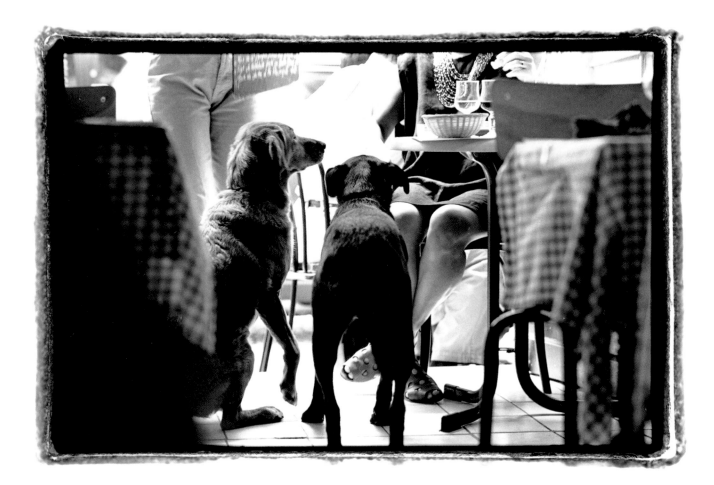

At a cute bistro politely we begged:

Please, just a morsel; it worked, we got fed!

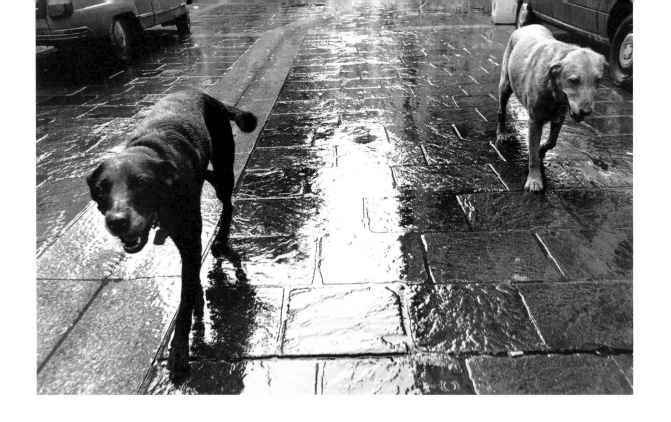

Then outside it rained and, soaked to the bone,

we headed chez nous and called the day done.

But sun the next day called for

un pique-nique

so we made up a list and raced off real quick.

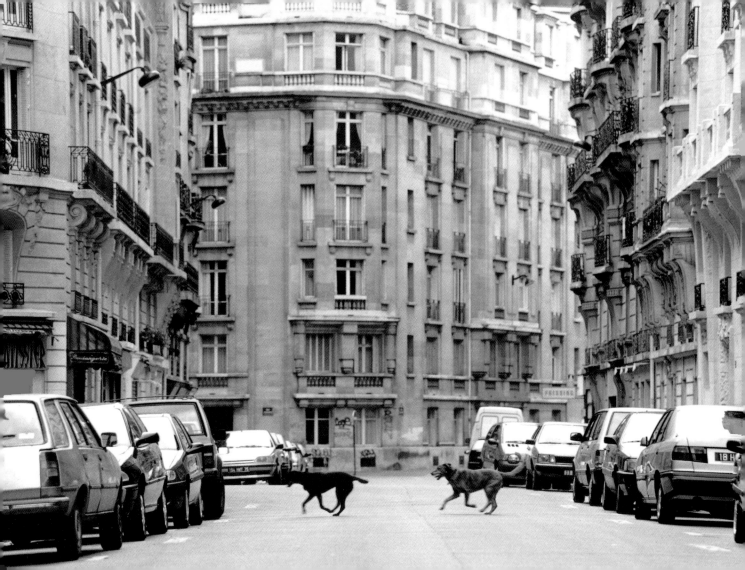

For meat, au boucher, where with one hungry look

we spied sweet saucissons up high on a hook.

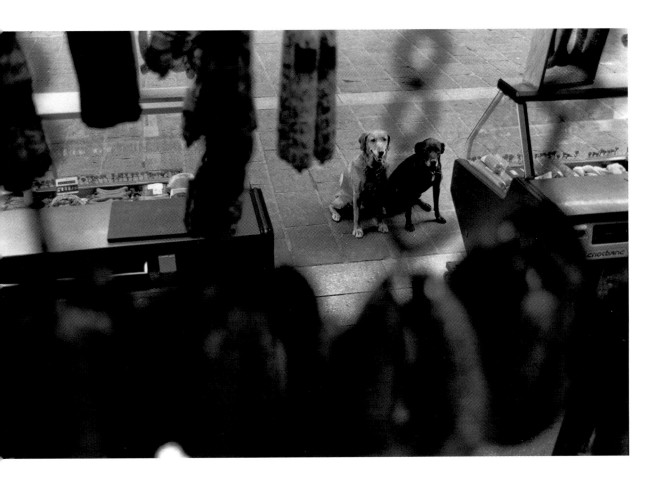

La boulangerie had lots of sweet treats,

but we bought une baguette

to go with our meat.

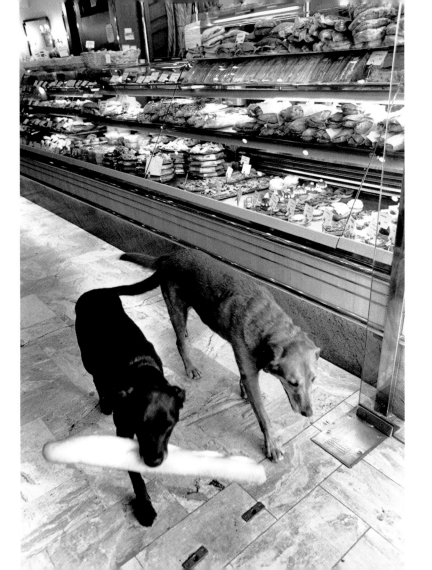

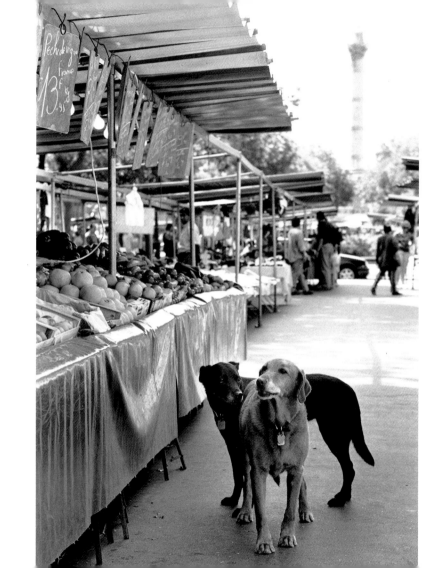

The open-air market out by la Bastille

provided the fruit to round out our meal.

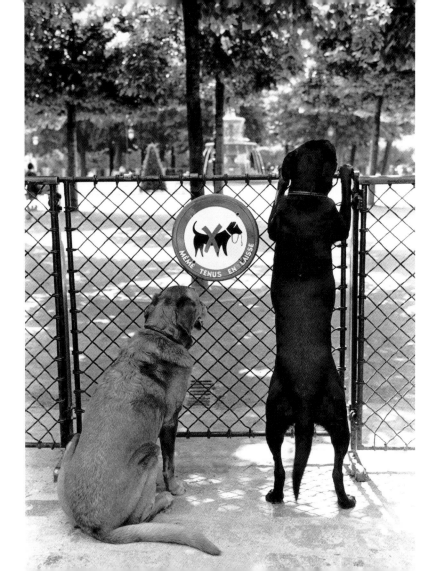

La Place des Vosges was green with no crowds,

but to our dismay we were not allowed.

Undaunted we crisscrossed la ville till we found

a spot with a view and plunked ourselves down.

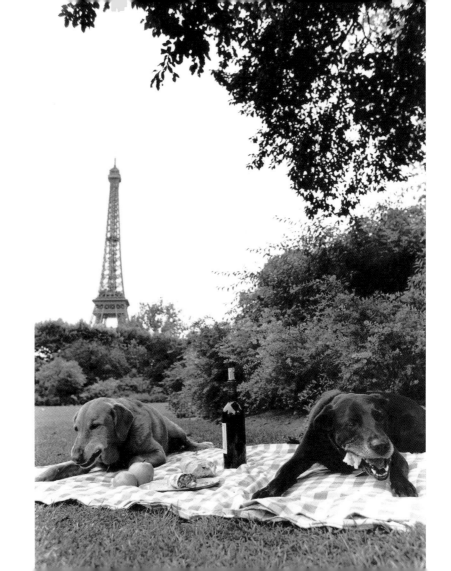

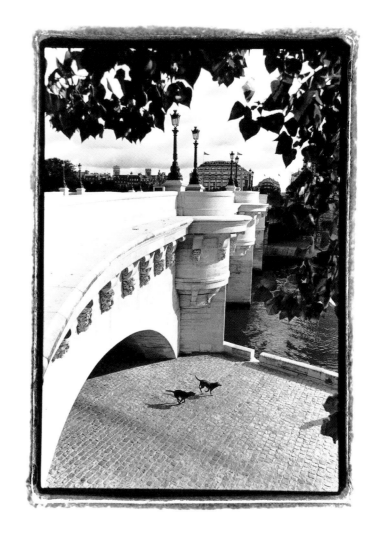

After all that, exercise was in order—

we ran by la Seine

and then hit the water.

A spot to cool off is what every dog needs,

so we dipped our paws at

la Place St. Placide.

Big and refreshing and deep as a well,

but not so grand as la Place St. Michel

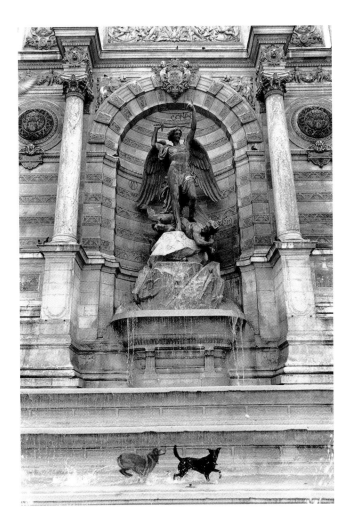

Back on the Right Bank we dove with panache

into the long pool by l'église St. Eustache.

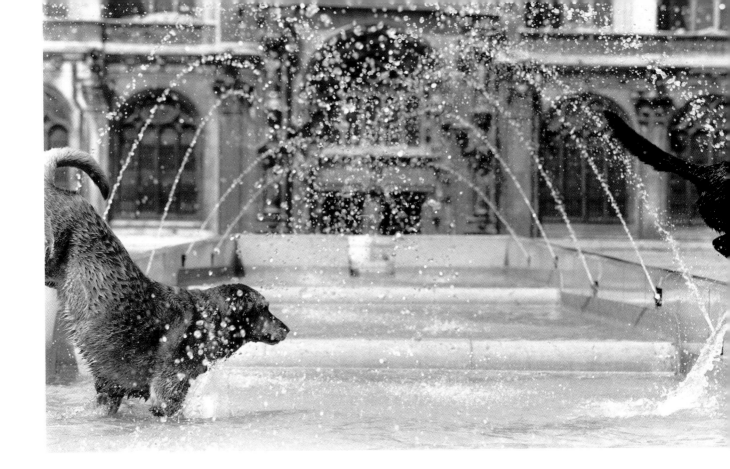

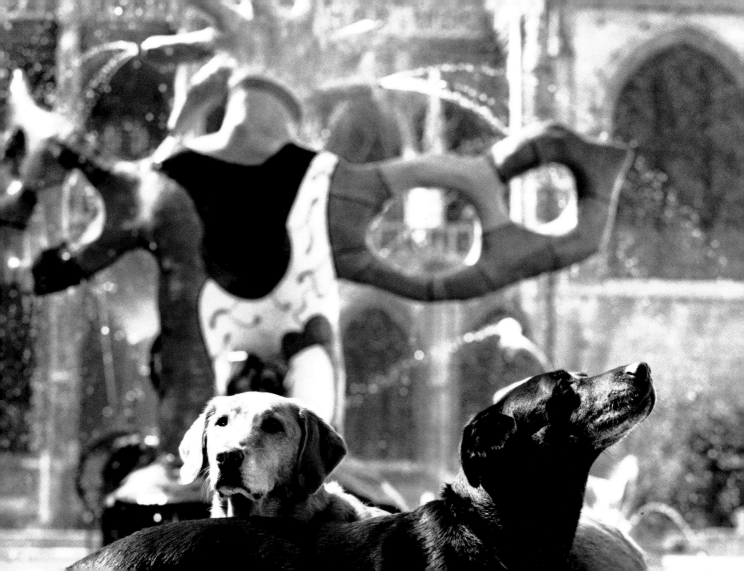

La Fontaine Stravinski

left us amazed,

entranced by the sculpture that moved as it sprayed!

At Père Lachaise we braved all the gloom to pay our respects at Jim Morrison's tomb.

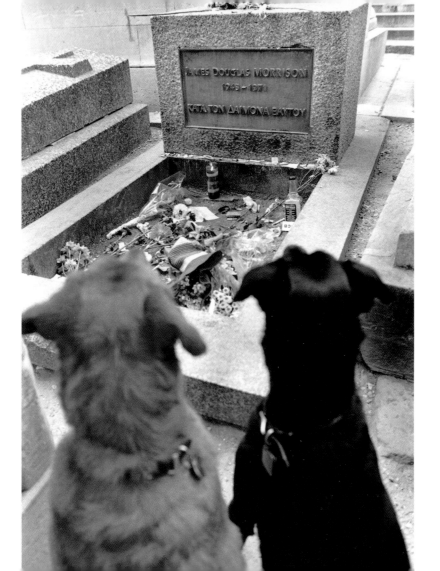

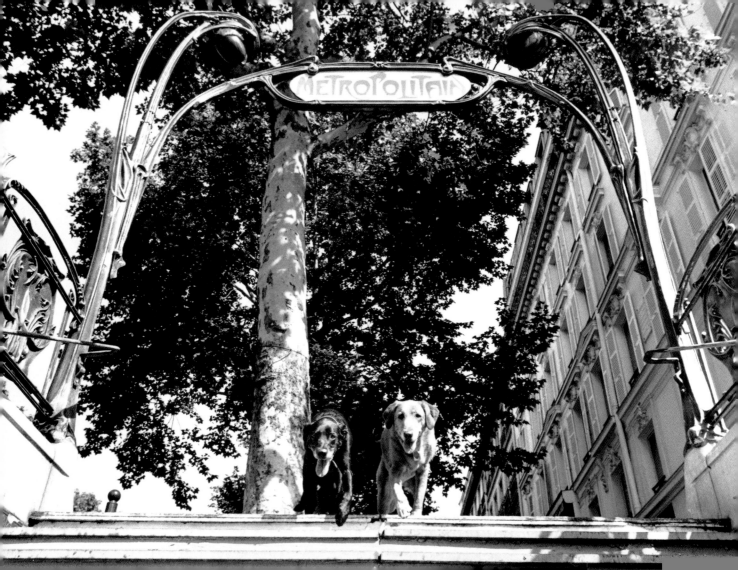

With so many places left yet to go,

on this, our last day, we tried le Métro

Back above ground au kiosque à journaux

we bought a newspaper to choose where to go.

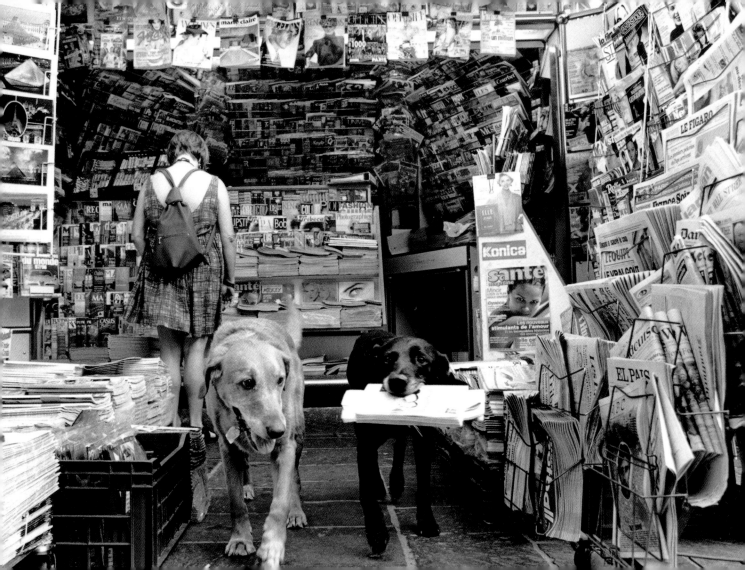

We wanted mementos that we could take back,

and les quais bouquinistes

had lots we could pack.

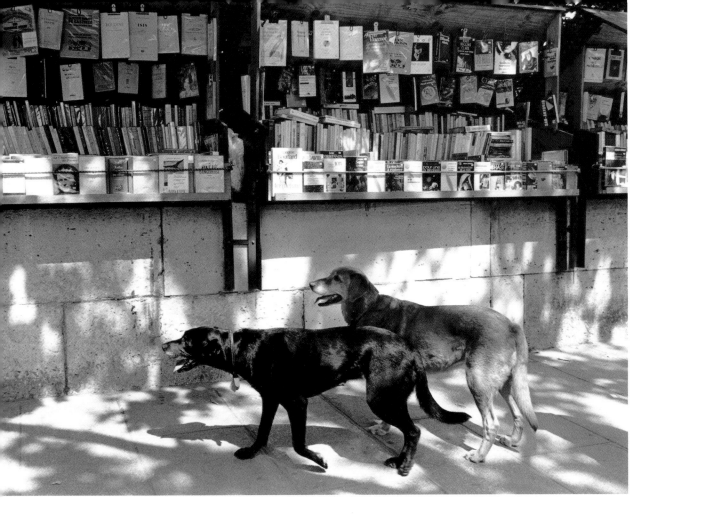

Au marché at Cité,

we found the birds pretty

but locked in a cage. Oh dear, what a pity!

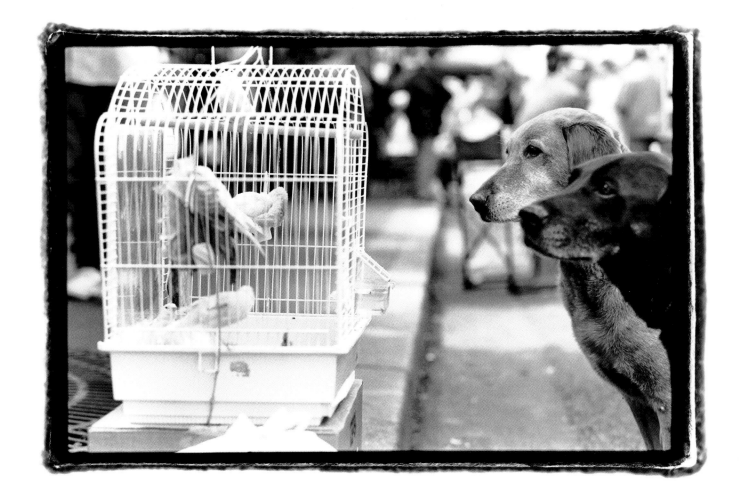

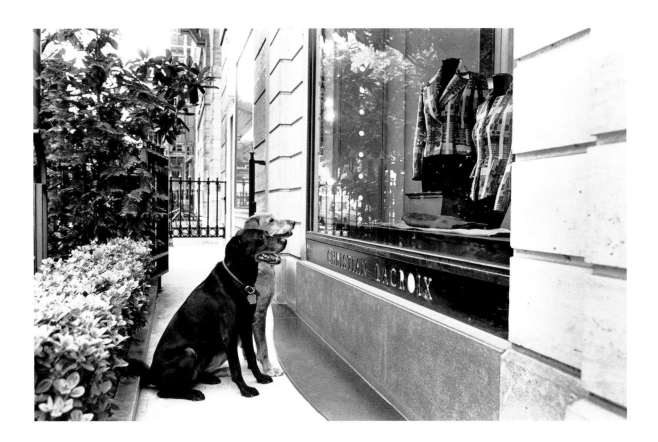

Back out in the Eighth, la mode caught our eye,

but the sizes were wrong, the prices too high.

Never defeated, we canines got smart

and sat for a portrait up at Montmartre.

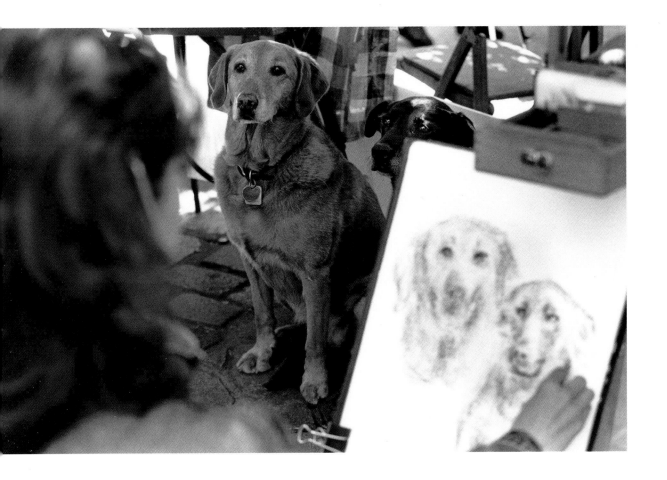

We said au revoir at our favorite café

and then headed out for one last soirée.

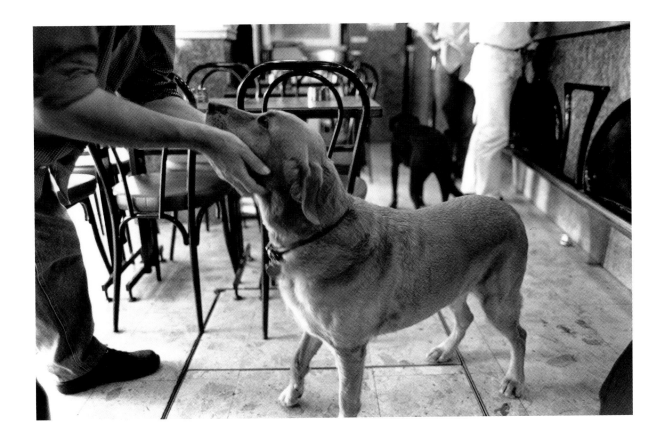

Le Moulin Rouge

should have been just the thing,

but it wouldn't be rocking in time for our fling.

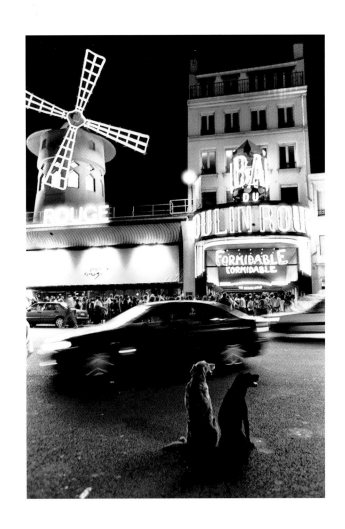

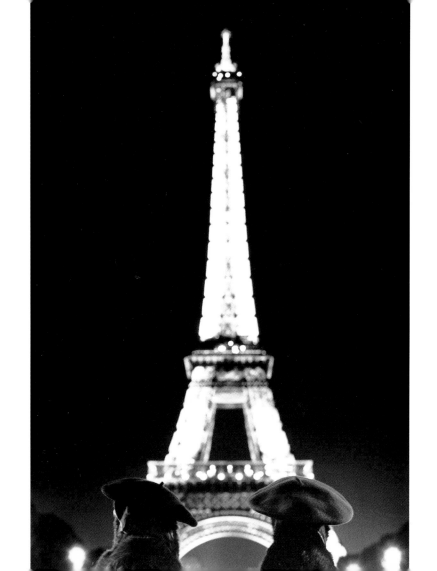

So, we raced off instead to that magical sight,

the famed Tour Eiffel all lit up at night.

afterword

Betty, born in April 1987, came into our lives almost immediately after the birth of our daughter. Betty is half golden retriever, half yellow lab, and all dog— sweet, loyal, protective, and utterly indiscriminate about what, when, why, and where she eats. Rita, born in August 1991, gained entry into the family because Judith provided Michael with an acceptable name for a second dog. She is half lab, half pitbull (we suspect), and all baby—a crooner, a total wimp, and a glutton for attention, having had the luxury of a big "sister," who fortu-nately got over her distaste for this competition after only twenty-four hours. The two have been inseparable ever since. To know them and see them wrapped around one another in sleep is to understand more deeply the yin and yang of life.

To say we all enjoyed making this book would be an understatement. When Michael would announce an out-ing by asking, "Are you ready to go to work?" the dogs would spring to life. (Of course, knowing canine hearing and language skills, they might have mis-taken "work" for "walk," but it didn't matter, as they rose to each occasion to perform with enthusiasm.) The first photo we took was of the dogs looking wistfully into the entrance of the Place des Vosges; we knew we had a winner

when a tourist stood behind Michael and took the same picture for her scrapbook! Photographing them in front of the Picasso Museum, we had fun noting the different reactions between tourists on their way in (quizzical) and those on their way out (hysterical)—clear evidence that museums can be both fun and educational.

Anyone who has ever been to Paris surely knows that the first response to a request of any kind is a polite but firm *non*. Anyone who has ever lived there knows that, whatever one is first told, with some patience and ingenuity it is possible to do almost anything. So when we decided to photograph Betty and Rita at Jim Morrison's grave, fully aware that dogs are not allowed into Père Lachaise cemetery, we went armed with previous shots in the series. When the guard approached, Michael flourished these examples, and she generously waved us on with a smile and a quick *"dépêchez-vous."*

Still, this book would not have been imaginable, much less possible, without the ever-present assistance and encouragement of the Parisians—the waiter who fed the dogs sugar cubes at the café, the baker who let us edge into her busy shop, the butcher who loaned us a ladder, the *vendeuses* at the *couturiers* who whistled and tapped the windows to attract the dogs' attention, and especially all our friends who supplied us with an endless stream of suggestions for the quintessential Parisian experience. Thank you, Paris, from the bottom of our hearts.

à bientôt